Conundrums

itbooks

AN IMPRINT OF HARPERCOLLINS*PUBLISHERS*

Co
n
un
n
dr
um
s

Typographic conundrums
Harry Pearce

HarperCollins books may be purchased for educational, business, or sales promotional use. For information please write: Special Markets Department, HarperCollins Publishers, 10 East 53rd Street, New York, NY 10022.

Designed by Pentagram
Set in AG Old Face

FIRST EDITION

ISBN 978-0-06-182659-7

09 10 11 12 13 10 9 8 7 6 5 4 3 2 1

THANKS

For Colli, with eternal love and gratitude.

With thanks to:

Alan Fletcher for his original encouragement, Terron Schaefer at Saks without whom this would not exist, my parents and the collective fun of my family, Ron and June, Jo and Austin, Monica and Chris, Josh, Ben, Jake, Rory, Nick, Victoria and Lizzie. A lifetime of wonderful friendships – you know who you are! All my Pentagram partners. My wonderful team: Jason Ching, Daren Howells, Kate O'Brien, Ellie Columbine and Hugh Roberts, and so many in the past. John Simmons for textural massaging. And finally the countless numbers of people who've insisted I do this.

I grew up in an age and a home where the words of Spike Milligan, Edward Lear, Peter Cook and Monty Python, among many others, filled the air. Nonsense that made sense; irreverence that became pure pleasure.

Words became images, images words, and where was the line between the two?

It didn't matter as long as they gave you a smile of recognition.

So, visual games with words have stayed with me. And, strangely, these little games seem to have a life of their own. I started them years ago, a love affair between typography and phrase, and they've been one step ahead of me ever since.

Now, there's a conundrum. Much as I want to capture these secrets, they always stay just out of reach. So I have to keep following in their footsteps but always sticking to the rules: one box, only two colours, just a single typeface.

Sometimes the more cornered you are, the more fun you have.

Harry Pearce
London 31/5/2009

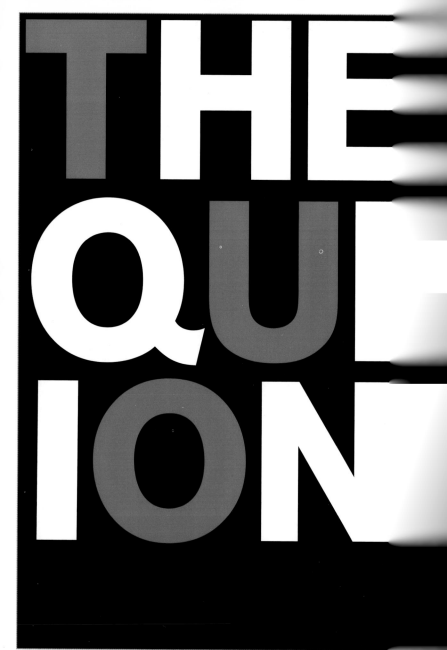

EST

WORKWORKWORKWORK
WORKWORKWORKWORK
WORKWORKWORKWORK
WORKWORKWORKWORK
WORKWORKWORKWORK
WORKWORKWORKWORK
WORKWORKWORKWORK
WORKWORKWORKWORK
WORKWORKWORKWORK

RNOAD

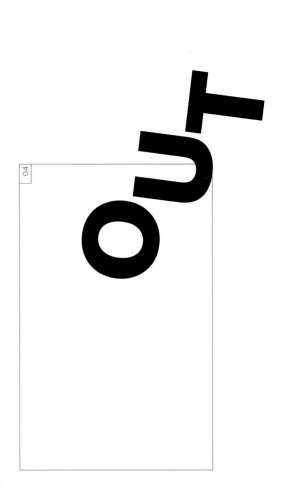

OUT

04

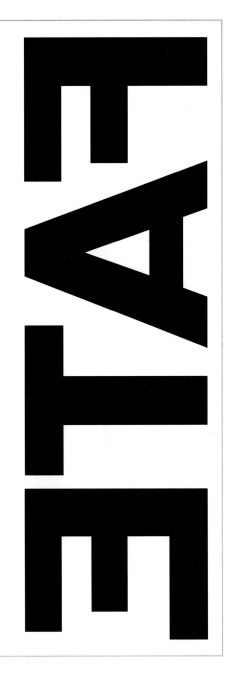

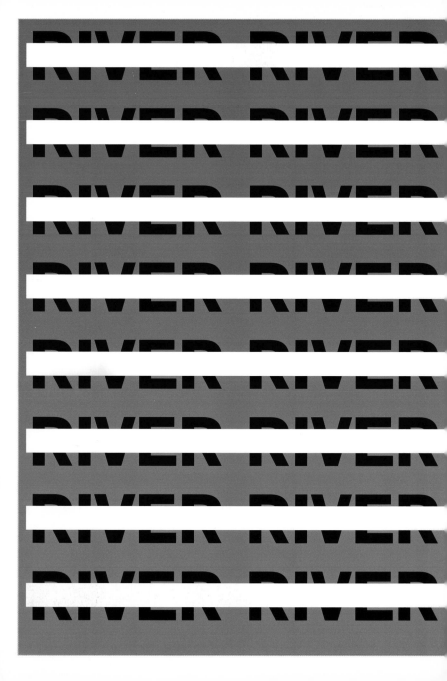

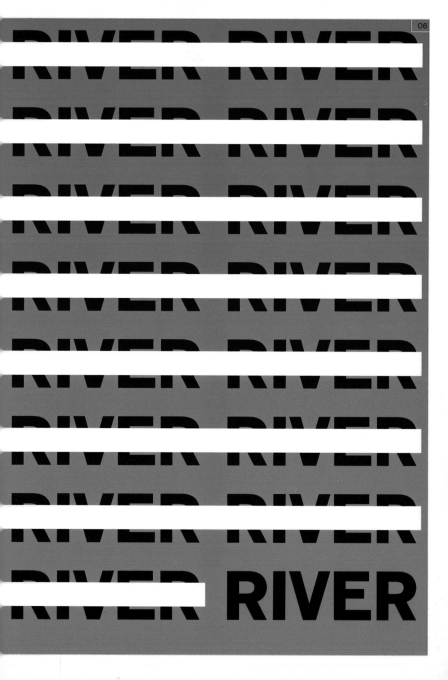

SHEEP

DOOR FOOT

GAME

B E

BUSH

A T

HEARTED

QUARTERS

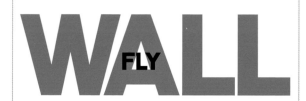

FLY ON THE WALL

COME **SHORT**

HEADS
HEADS
HEADS
HEADS
HEADS
HEADS
HEADS
HEADS

MOUTH

DOGS CATS DOGS CATS

DOGS CATS
DOGS CATS DOGS CATS DOGS
DOGS CATS DOGS CATS DOGS CATS DOGS CATS DOGS
CATS DOGS CATS DOGS CATS DOGS CATS DOGS CATS
CATS DOGS CATS DOGS CATS DOGS CATS DOGS
DOGS
CATS DOGS
CATS DOGS CATS DOGS CATS DOGS CATS DOGS CATS DOGS
CATS DOGS CATS DOGS CATS DOGS CATS DOGS CATS DOGS
CATS DOGS CATS DOGS CATS DOGS CATS DOGS CATS
DOGS CATS
CATS DOGS CATS DOGS CATS DOGS CATS DOGS CATS
DOGS CATS DOGS CATS DOGS CATS DOGS CATS DOGS CATS
DOGS CATS DOGS CATS DOGS CATS DOGS CATS
DOGS CATS DOGS CATS DOGS CATS
CATS DOGS
DOGS CATS DOGS CATS DOGS CATS DOGS CATS DOGS CATS
DOGS CATS DOGS CATS DOGS CATS DOGS CATS
CATS
DOGS CATS DOGS CATS DOGS CATS DOGS CATS DOGS
DOGS CATS DOGS CATS DOGS CATS DOGS
DOGS CATS DOGS CATS DOGS CATS DOGS CATS DOGS
DOGS CATS DOGS CATS DOGS CATS DOGS CATS DOGS CATS
CATS DOGS CATS DOGS CATS DOGS CATS DOGS CATS
DOGS CATS DOGS CATS DOGS CATS DOGS CATS
DOGS CATS DOGS CATS DOGS CATS DOGS CATS DOGS CATS
CATS DOGS CATS DOGS CATS DOGS CATS DOGS CATS DOGS
CATS DOGS CATS DOGS CATS DOGS CATS DOGS CATS DOGS
CATS DOGS CATS DOGS CATS DOGS CATS DOGS CATS
DOGS CATS DOGS CATS DOGS CATS DOGS CATS DOGS CATS DOGS
CATS DOGS CATS DOGS CATS DOGS CATS DOGS CATS DOGS
CATS DOGS CATS DOGS CATS DOGS CATS DOGS CATS DOGS
CATS DOGS CATS DOGS CATS DOGS CATS DOGS CATS DOGS CATS
DOGS CATS DOGS CATS DOGS CATS DOGS CATS DOGS CATS
CATS DOGS CATS DOGS CATS DOGS CATS DOGS CATS DOGS CATS
CATS DOGS CATS DOGS CATS DOGS CATS DOGS CATS DOGS CATS DOGS
CATS DOGS CATS DOGS CATS DOGS CATS DOGS CATS DOGS CATS DOGS
CATS DOGS CATS DOGS CATS DOGS CATS DOGS CATS DOGS CATS DOGS

LIFE

HE
ADA
CHE

0, ,2
3,4,5

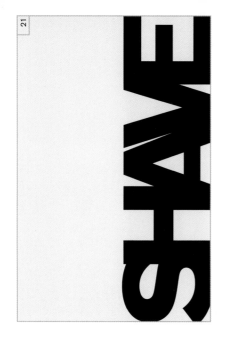

21

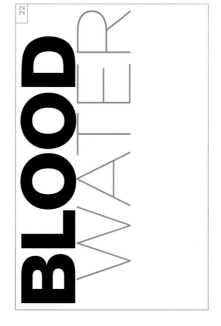

22

DICK

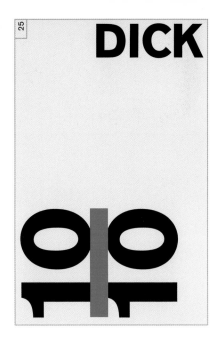

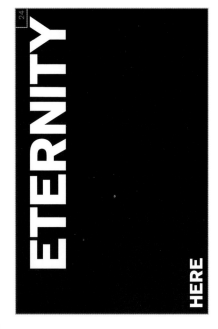

ETERNITY

HERE

COURT

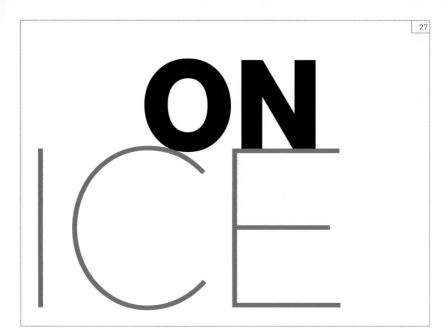

ALL DAY'S WORK

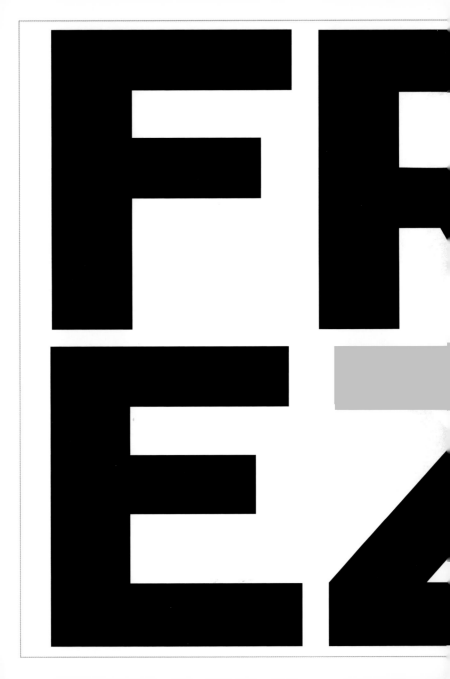

AGAINST
CLOCK

666666
777777

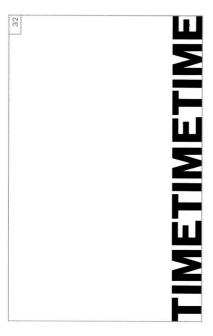

TIMETIMETIME

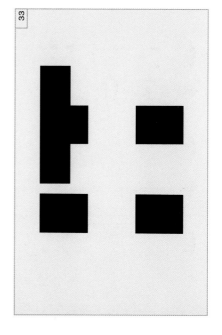

STOOGE
STOOGE
STOOGE

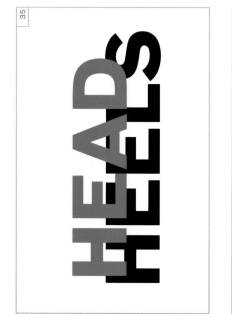

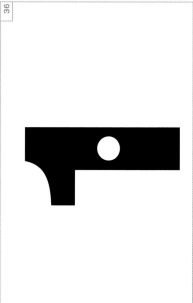

LEGS
TAIL
LEGS

LESS

MORE

ILNOOK
ABNAGCE
KR

FREU

DIAN

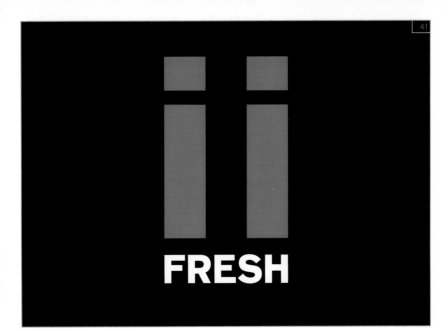

FRESH

PRO
MI
SE

GLANCE

SCREW

RINGER

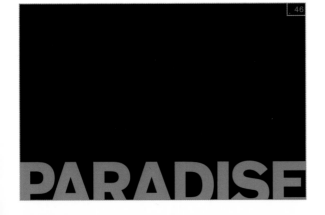

BELL SAVED

KOOL
LOOK
LOOK

1G2A
3M4E

WALL

ABCDEFGHIJKLMNOPQRSTUVWXYZ

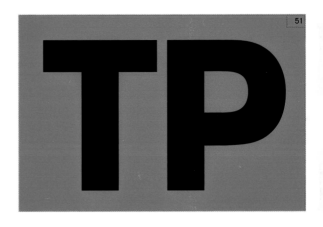

51

52

WFAITSEHR

SQU
ARE

FAIR

EGG
EGG
EGG

BELLY

H²O!

"SHOP"

FOOT
FOOT
SHOE

INSULT
INJURY

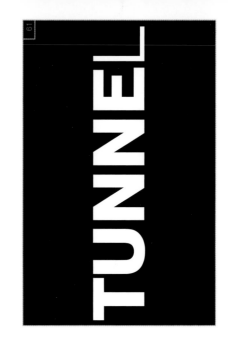

TUNNEL

CREAM

SMOKE
SMOKE

FIRE

FUEL

EVEN

RO**FORK**AD

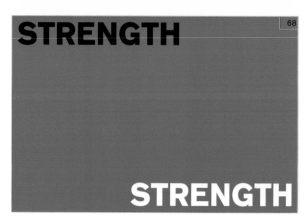

STRENGTH

STRENGTH

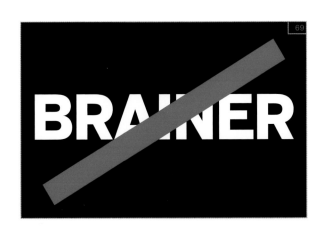

69 BRAINER

70

1 END
3 END
5 END

a

EARS EARS EARS EARS EARS EARS EARS EARS EARS EARS
EARS EARS EARS EARS EARS EARS EARS EARS EARS EARS
EARS EARS EARS EARS EARS EARS EARS EARS EARS EARS
EARS EARS EARS EARS EARS EARS EARS EARS EARS EARS
EARS EARS EARS EARS EARS EARS EARS EARS EARS EARS
EARS EARS EARS EARS EARS EARS EARS EARS EARS EARS
EARS EARS EARS EARS EARS EARS EARS EARS EARS EARS
EARS EARS EARS EARS EARS EARS EARS EARS EARS EARS
EARS EARS EARS EARS EARS EARS EARS EARS EARS EARS
EARS EARS EARS EARS EARS EARS EARS EARS EARS EARS
EARS EARS EARS EARS EARS EARS EARS EARS EARS EARS
EARS EARS EARS EARS EARS EARS EARS EARS EARS EARS
EARS EARS EARS EARS EARS EARS EARS EARS EARS EARS
EARS EARS EARS EARS EARS EARS EARS EARS EARS EARS
EARS EARS EARS EARS EARS EARS EARS EARS EARS EARS
EARS EARS EARS EARS EARS EARS EARS EARS EARS EARS
EARS EARS EARS EARS EARS EARS EARS EARS EARS EARS
EARS EARS EARS EARS EARS EARS EARS EARS EARS EARS
EARS EARS EARS EARS EARS EARS EARS EARS EARS EARS
EARS EARS EARS EARS EARS EARS EARS EARS EARS EARS
EARS EARS EARS EARS EARS EARS EARS EARS EARS EARS
EARS EARS EARS EARS EARS EARS EARS EARS EARS EARS
EARS EARS EARS EARS EARS EARS EARS EARS EARS EAR
EARS EARS EARS EARS EARS EARS EARS EARS EARS EARS
EARS EARS EARS EARS EARS EARS EARS EARS EARS EARS
EARS EARS EARS EARS EARS EARS EARS EARS EARS EARS
EARS EARS EARS EARS EARS EARS EARS EARS EARS EARS
EARS EARS EARS EARS EARS EARS EARS EARS EARS EARS
EARS EARS EARS EARS EARS EARS EARS EARS EARS EAR
EARS EARS EARS EARS EARS EARS EARS EARS EARS EARS
EARS EARS EARS EARS EARS EARS EARS EARS EARS EARS
EARS EARS EARS EARS EARS EARS EARS EARS EARS EARS
EARS EARS EARS EARS EARS EARS EARS EARS EARS EARS
EARS EARS EARS EARS EARS EARS EARS EARS EARS EARS
EARS EARS EARS EARS EARS EARS EARS EARS EARS EARS
EARS EARS EARS EARS EARS EARS EARS EARS EARS EARS

ARS EARS EARS EARS EARS EARS EARS EARS EARS EARS
ARS EARS EARS EARS EARS EARS EARS EARS EARS EARS
ARS EARS EARS EARS EARS EARS EARS EARS EARS EARS
ARS EARS EARS EARS EARS EARS EARS EARS EARS EARS
ARS EARS EARS EARS EARS EARS EARS EARS EARS EARS
ARS EARS EARS EARS EARS EARS EARS EARS EARS EARS
ARS EARS EARS EARS EARS EARS EARS EARS EARS EARS
ARS EARS EARS EARS EARS EARS EARS EARS EARS EARS
ARS EARS EARS EARS EARS EARS EARS EARS EARS EARS
ARS EARS EARS EARS EARS EARS EARS EARS EARS EARS
ARS EARS EARS EARS EARS EARS EARS EARS EARS EARS
ARS EARS EARS EARS EARS EARS EARS EARS EARS EARS
ARS EARS EARS EARS EARS EARS EARS EARS EARS EARS
ARS EARS EARS EARS EARS EARS EARS EARS EARS EARS
ARS EARS EARS EARS EARS EARS EARS EARS EARS EARS
ARS EARS EARS EARS EARS EARS EARS EARS EARS EARS
ARS EARS EARS EARS EARS EARS EARS EARS EARS EARS
ARS EARS EARS EARS EARS EARS EARS EARS EARS EARS
ARS EARS EARS EARS EARS EARS EARS EARS EARS EARS
ARS EARS EARS EARS EARS EARS EARS EARS EARS EARS
ARS EARS EARS EARS EARS EARS EARS EARS EARS EARS
ARS EARS EARS EARS EARS EARS EARS EARS EARS EARS
ARS EARS EARS EARS EARS EARS EARS EARS EARS EARS
ARS EARS EARS EARS EARS EARS EARS EARS EARS EARS
ARS EARS EARS EARS EARS EARS EARS EARS EARS EARS
ARS EARS EARS EARS EARS EARS EARS EARS EARS EARS
ARS EARS EARS EARS EARS EARS EARS EARS EARS EARS
ARS EARS EARS EARS EARS EARS EARS EARS EARS EARS
ARS EARS EARS EARS EARS EARS EARS EARS EARS EARS
ARS EARS EARS EARS EARS EARS EARS EARS EARS EARS
ARS EARS EARS EARS EARS EARS EARS EARS EARS EARS
ARS EARS EARS EARS EARS EARS EARS EARS EARS EARS
ARS EARS EARS EARS EARS EARS EARS EARS EARS EARS
ARS EARS EARS EARS EARS EARS EARS EARS EARS EARS

LOOK

HERE
THERE

LAID

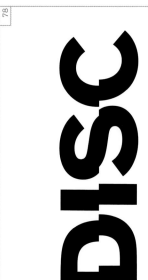

DISC

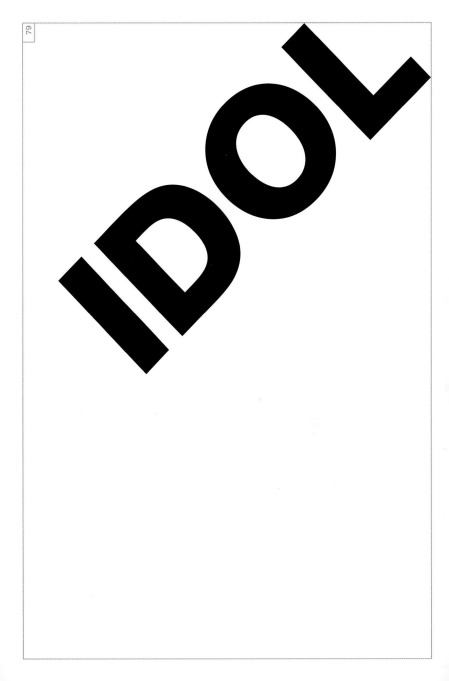

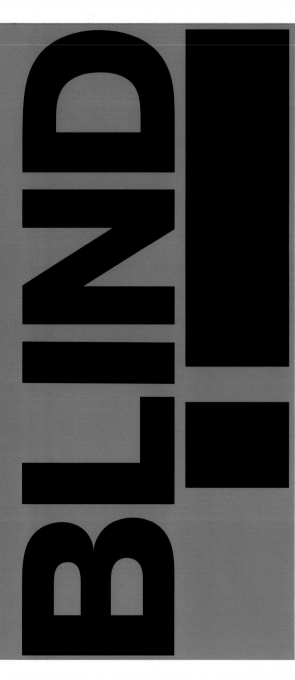

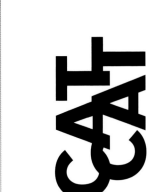

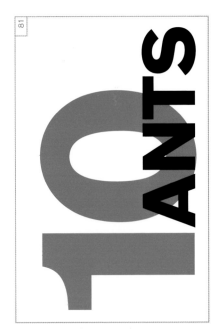

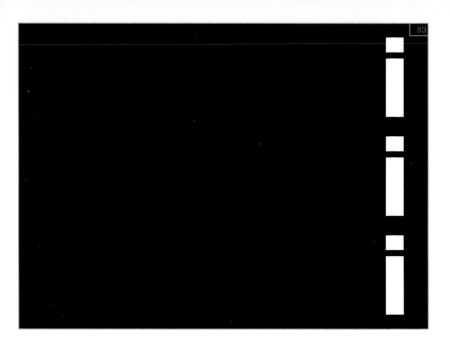

YOU JUST ME

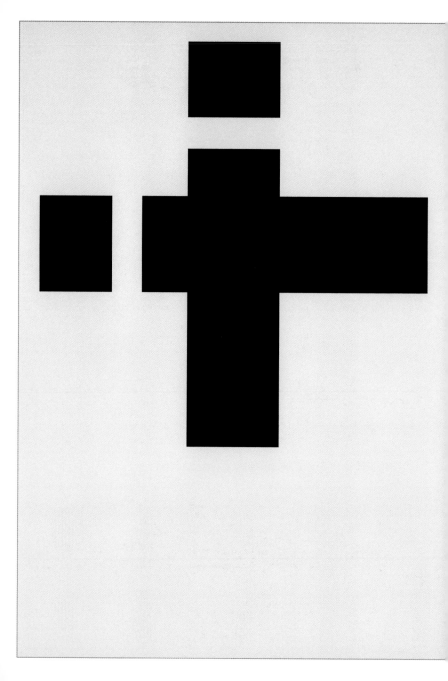

ED

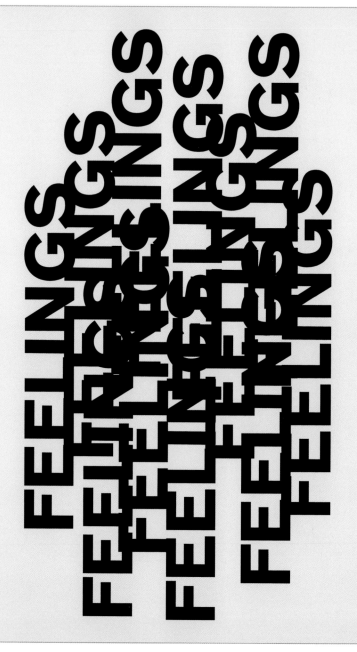

C

UT

MANOEUVRE

LE

G

COMPANY
COMPANY
CROWD
CROWD
CROWD

OUT

TRAVEL

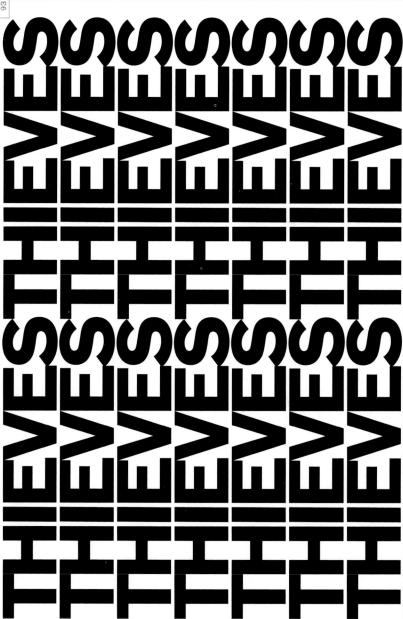

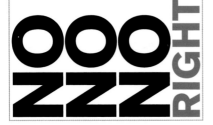

LIE

GONE
FORG

OTTEN

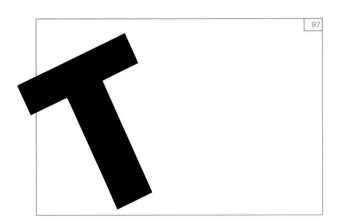

ci2i

TEARS

GERNEVEYN

GROUND

COVER

"PILLOW"

EXPLOSIVE

HEART

GIVEXIV GETX IV

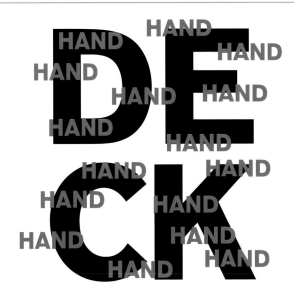

DECK
HAND HAND HAND HAND HAND HAND HAND HAND HAND HAND HAND HAND HAND HAND HAND

SNOWED

PPPP**OD**

LOOK LEAP

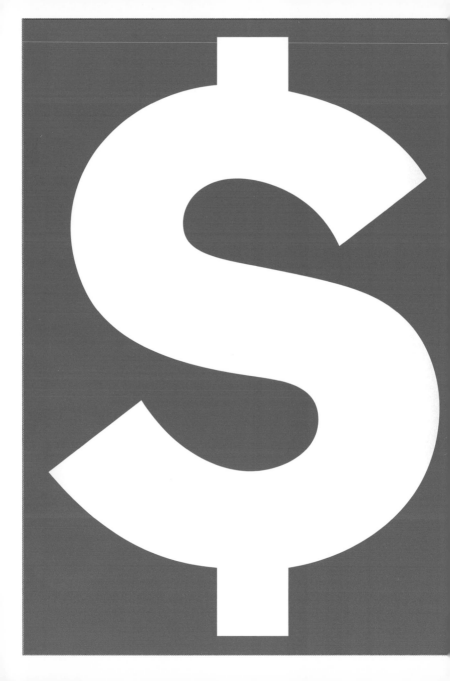

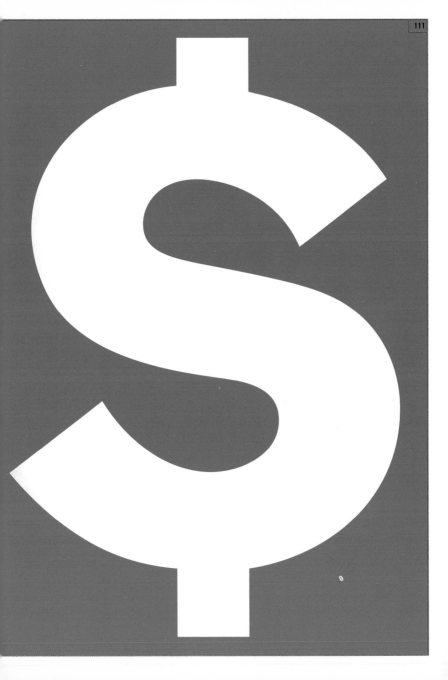

PASS
UNDER

ACTION!

WORDS

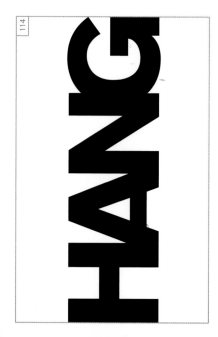

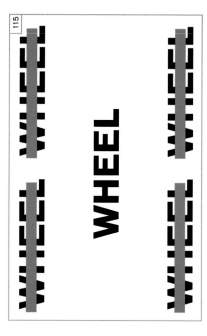

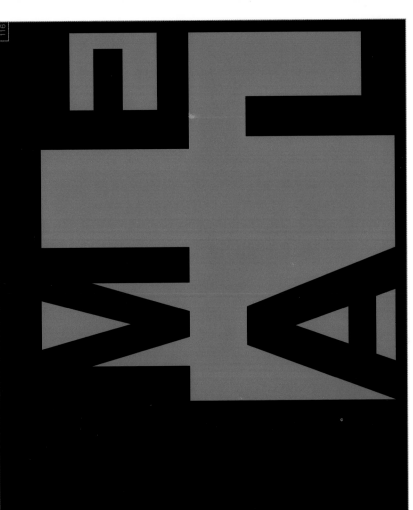

NOT

OVER
TOP

FINGERS
FINGERS

HEADS

ARM
LEG
$

OUT
LIMB

HEART
HAND

SU

IT

E

WRITING

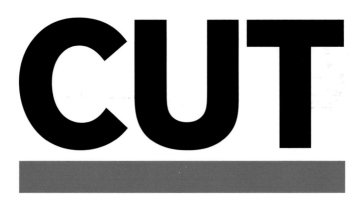

PANTS

FLATS

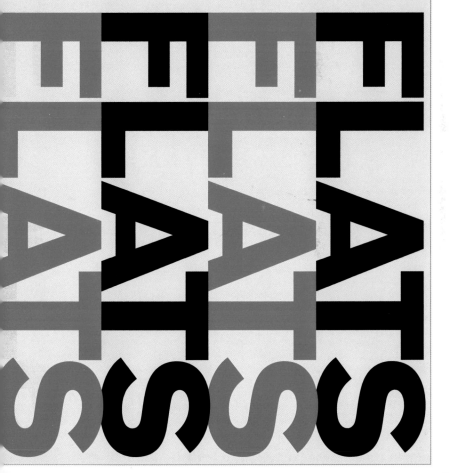

THINGS THINGS THINGS THINGS THINGS THINGS THINGS THINGS THINGS THING
THINGS THINGS THINGS THINGS THINGS THINGS THINGS THINGS THINGS THING
THINGS THINGS THINGS THINGS THINGS THINGS THINGS THINGS THINGS THING
THINGS THINGS THINGS THINGS THINGS THINGS THINGS THINGS THINGS THING
THINGS THINGS THINGS THINGS THINGS THINGS THINGS THINGS THINGS THING
THINGS THINGS THINGS THINGS THINGS THINGS THINGS THINGS THINGS THING
THINGS THINGS THINGS THINGS THINGS THINGS THINGS THINGS THINGS THING
THINGS THINGS THINGS THINGS THINGS THINGS THINGS THINGS THINGS THING
THINGS THINGS THINGS THINGS THINGS THINGS THINGS THINGS THINGS THING
THINGS THINGS THINGS THINGS THINGS THINGS THINGS THINGS THINGS THING
THINGS THINGS THINGS THINGS THINGS THINGS THINGS THINGS THINGS THING
THINGS THINGS THINGS THINGS THING THINGS
THINGS THINGS THINGS THINGS THING THINGS
THINGS THINGS THINGS THINGS THING THINGS
THINGS THINGS THINGS THINGS THING THINGS
THINGS THINGS THINGS THINGS THING THINGS
THINGS THINGS THINGS THINGS THING THINGS
THINGS THINGS THINGS THINGS THING THINGS
THINGS THINGS THINGS THINGS THING THINGS
THINGS THINGS THINGS THINGS THING THINGS
THINGS THINGS THINGS THINGS THING THINGS
THINGS THINGS THINGS THINGS THING THINGS
THINGS THINGS THINGS THINGS THING THINGS
THINGS THINGS THINGS THINGS THING THINGS
THINGS THINGS THINGS THINGS THING THINGS
THINGS THINGS THINGS THINGS THING THINGS
THINGS THINGS THINGS THINGS THING THINGS
THINGS THINGS THINGS THINGS THING THINGS
THINGS THINGS THINGS THINGS THING THINGS
THINGS THINGS THINGS THINGS THING THINGS
THINGS THINGS THINGS THINGS THING THINGS
THINGS THINGS THINGS THINGS THING THINGS
THINGS THINGS THINGS THINGS THING THINGS
THINGS THINGS THINGS THINGS THING THINGS
THINGS THINGS THINGS THINGS THING THINGS
THINGS THINGS THINGS THINGS THING THINGS
THINGS THINGS THINGS THINGS THING THINGS
THINGS THINGS THINGS THINGS THINGS THINGS THINGS THINGS THINGS THING
THINGS THINGS THINGS THINGS THINGS THINGS THINGS THINGS THINGS THING
THINGS THINGS THINGS THINGS THINGS THINGS THINGS THINGS THINGS THING
THINGS THINGS THINGS THINGS THINGS THINGS THINGS THINGS THINGS THING
THINGS THINGS THINGS THINGS THINGS THINGS THINGS THINGS THINGS THING
THINGS THINGS THINGS THINGS THINGS THINGS THINGS THINGS THINGS THING
THINGS THINGS THINGS THINGS THINGS THINGS THINGS THINGS THINGS THING
THINGS THINGS THINGS THINGS THINGS THINGS THINGS THINGS THINGS THING
THINGS THINGS THINGS THINGS THINGS THINGS THINGS THINGS THINGS THING

THINGS THINGS THINGS THINGS THINGS THINGS THINGS THINGS THINGS THINGS THINGS
THINGS THINGS THINGS THINGS THINGS THINGS THINGS THINGS THINGS THINGS THINGS
THINGS THINGS THINGS THINGS THINGS THINGS THINGS THINGS THINGS THINGS THINGS
THINGS THINGS THINGS THINGS THINGS THINGS THINGS THINGS THINGS THINGS THINGS
THINGS THINGS THINGS THINGS THINGS THINGS THINGS THINGS THINGS THINGS THINGS
THINGS THINGS THINGS THINGS THINGS THINGS THINGS THINGS THINGS THINGS THINGS
THINGS THINGS THINGS THINGS THINGS THINGS THINGS THINGS THINGS THINGS THINGS
THINGS THINGS THINGS THINGS THINGS THINGS THINGS THINGS THINGS THINGS THINGS
THINGS THINGS THINGS THINGS THINGS THINGS THINGS THINGS THINGS THINGS THINGS
THINGS THINGS THINGS THINGS THINGS THINGS THINGS THINGS THINGS THINGS THINGS
THINGS THINGS THINGS THINGS THINGS THINGS THINGS THINGS THINGS THINGS THINGS
THINGS THINGS THINGS THINGS THINGS THINGS THINGS THINGS
THINGS THINGS THINGS THINGS THINGS THINGS THINGS THINGS
 INGS THINGS THINGS THINGS THINGS THINGS THINGS THINGS
 GS THINGS THINGS THINGS THINGS THINGS THINGS THINGS
 S THINGS THINGS THINGS THINGS THINGS THINGS THINGS
 THINGS THINGS THINGS THINGS THINGS THINGS THINGS
 THINGS THINGS THINGS THINGS THINGS THINGS THINGS
 INGS THINGS THINGS THINGS THINGS THINGS THINGS
 GS THINGS THINGS THINGS THINGS THINGS THINGS
 S THINGS THINGS THINGS THINGS THINGS THINGS
 THINGS THINGS THINGS THINGS THINGS THINGS
 THINGS THINGS THINGS THINGS THINGS THINGS
 INGS THINGS THINGS THINGS THINGS THINGS
 Th NGS THINGS THINGS THINGS THINGS THINGS
THI GS THINGS THINGS THINGS THINGS THINGS
THIN S THINGS THINGS THINGS THINGS THINGS
THING. THINGS THINGS THINGS THINGS THINGS
THINGS THINGS THINGS THINGS THINGS THINGS
THINGS 1 THINGS THINGS THINGS THINGS THINGS
THINGS Th THINGS THINGS THINGS THINGS THINGS
THINGS THI THINGS THINGS THINGS THINGS THINGS
THINGS THIN THINGS THINGS THINGS THINGS THINGS
THINGS THING. THINGS THINGS THINGS THINGS THINGS
THINGS THINGS THINGS THINGS THINGS THINGS THINGS
THINGS THINGS 1. THINGS THINGS THINGS THINGS THINGS
THINGS THINGS Th THINGS THINGS THINGS THINGS THINGS
THINGS THINGS THI THINGS THINGS THINGS THINGS THINGS
THINGS THINGS THIN THINGS THINGS THINGS THINGS THINGS
THINGS THINGS THING. THINGS THINGS THINGS THINGS THINGS
THINGS THINGS THINGS THINGS THINGS THINGS THINGS THINGS THINGS THINGS THINGS
THINGS THINGS THINGS THINGS THINGS THINGS THINGS THINGS THINGS THINGS THINGS
THINGS THINGS THINGS THINGS THINGS THINGS THINGS THINGS THINGS THINGS THINGS
THINGS THINGS THINGS THINGS THINGS THINGS THINGS THINGS THINGS THINGS THINGS
THINGS THINGS THINGS THINGS THINGS THINGS THINGS THINGS THINGS THINGS THINGS
THINGS THINGS THINGS THINGS THINGS THINGS THINGS THINGS THINGS THINGS THINGS
THINGS THINGS THINGS THINGS THINGS THINGS THINGS THINGS THINGS THINGS THINGS
THINGS THINGS THINGS THINGS THINGS THINGS THINGS THINGS THINGS THINGS THINGS

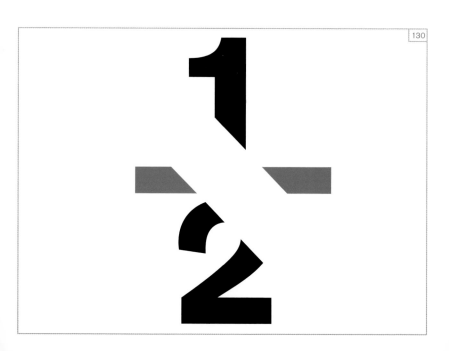

SHHH...

132

BF
BEOoeiENgs
OLNE S

133

CCCCC
C

WA YS

X
QQQ
ME

DRESSED
999

CANON

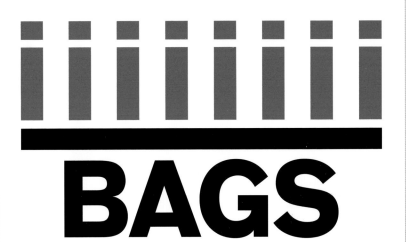

BAGS

UP
U

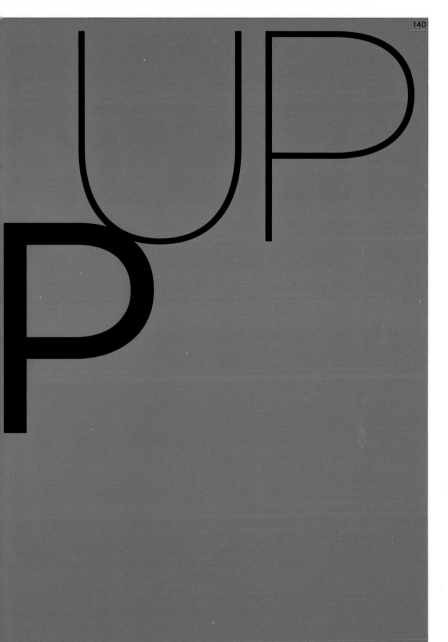

BLOCK

HA, HA, HA.
YOU

**WINK WINK
WINK WINK WINK WINK WINK
WINK WINK WINK WINK WINK
WINK WINK WINK WINK WINK
WINK WINK WINK WINK WINK
WINK WINK WINK WINK WINK
WINK WINK WINK WINK WINK
WINK WINK WINK WINK WINK
WINK WINK WINK**

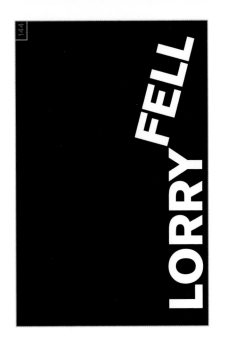

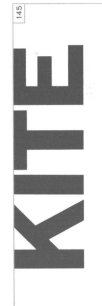

146

COCONUTS
COCONUTS
COCONUTS
COCONUTS
COCONUTS
COCONUTS
COCONUTS
COCONUTS
COCONUTS
COCONUTS
COCONUTS
COCONUTS
COCONUTS
COCONUTS

147

SYMPHON

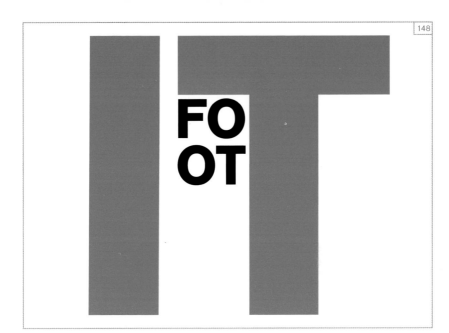

IT FOOT

FBAL
CUEE

MAIDEN

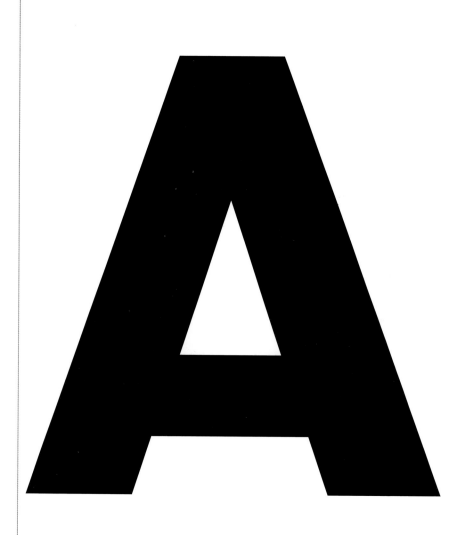

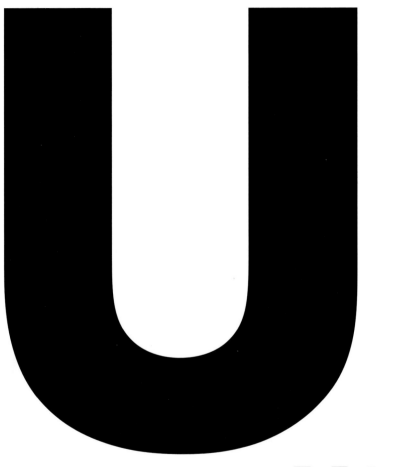

X2

IT

ME

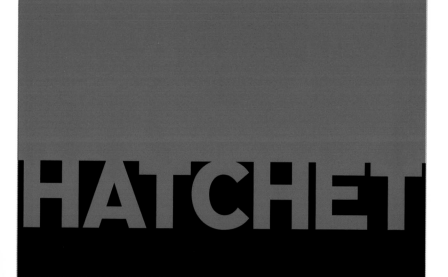

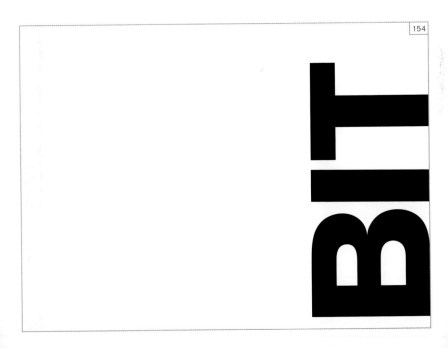

PAINTING

123456789

CASE

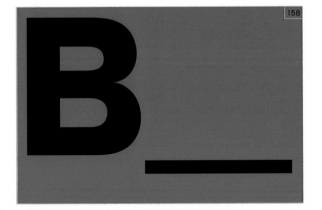

HAIR

END

? DADDY

34S6789A1
2345F7890
1E3456T89
012Y45678

FAMRIULNY

YOURSELF

SHOP

M
M

A
P

LEAP

MIDDLE

GOING

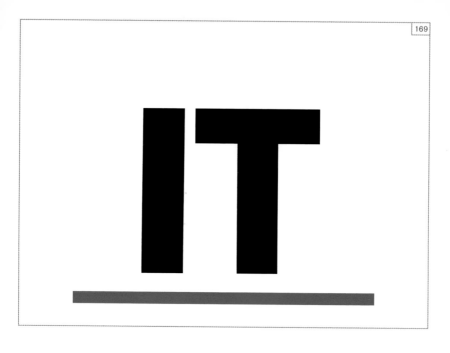

SH

OT

01 Out of the question
02 All work and no play
03 No through road
04 Falling out
05 A twist of fate
06 One more river to cross
07 Black sheep
08 A foot in the door
09 Raise your game
10 Beat around the bush
11 Open hearted
12 Close quarters
13 A fly on the wall
14 Come up short
15 Turning heads
16 Big mouth
17 Raining cats and dogs
18 A larger than life character
19 Splitting headache
20 No one
21 A close shave
22 Blood is thicker than water
23 God moves in mysterious ways
24 From here to eternity
25 Clever dick
26 Out of court
27 On thin ice
28 All in a day's work
29 The big freeze
30 Against the clock

31 All sixes and sevens
32 Time after time after time
33 The top and bottom of it
34 The three stooges
35 Head over heels
36 A hole in one
37 Tail between the legs
38 Less is more
39 Look back in anger
40 Freudian slip
41 A fresh pair of eyes
42 Broken promise
43 A sideways glance
44 Turn of the screw
45 Dead ringer
46 Paradise lost
47 Saved by the bell
48 Look both ways
49 Numbers game
50 The writing's on the wall
51 Tepee
52 The bottom line
53 A fish out of water
54 Fair and square
55 Scrambled eggs
56 Belly up
57 Flood warning
58 Talk shop
59 Shoe on the other foot
60 Add insult to injury

91 Blackout
92 Travel light
93 Thick as thieves
94 Right under your nose
95 A little white lie
96 Gone, but not forgotten
97 Tee off
98 See eye to eye
99 Burst into tears
100 Green with envy
101 Cover ground
102 Pillow talk
103 High explosive
104 Broken heart
105 Forgive and forget
106 Little by little
107 All hands on deck
108 Snowed under
109 Peas in a pod
110 Look before you leap
111 Big bucks
112 Underpass
113 Action speaks louder than words
114 Hang tight
115 Fifth wheel
116 Square meal
117 More often than not
118 Over the top
119 Fingers crossed
120 Heads-up

61 Light at the end of the tunnel
62 Vanishing cream
63 Holy smoke
64 Add fuel to the fire
65 A close call
66 Break even
67 Fork in the road
68 From strength to strength
69 No-brainer
70 Odds and ends
71 Okay by me
72 A fine line
73 Wet behind the ears
74 Look on the bright side
75 Neither here nor there
76 Laid back
77 A swarm of bees
78 Slipped disc
79 Fallen idol
80 Turn a blind eye
81 Tenants
82 Copycat
83 Eyes right
84 Just between you and me
85 Cross-eyed
86 Mixed feelings
87 Cut to pieces
88 No room to manoeuvre
89 Broken leg
90 Two's company, three's a crowd

121 Cost an arm and a leg
122 Out on a limb
123 Hand on heart
124 Three-piece suite
125 In writing
126 A cut above
127 Ants in your pants
128 Block of flats
129 In the thick of things
130 Half-cut
131 Silent night
132 A feeling in your bones
133 Seven seas
134 Six feet under
135 Separate ways
136 Excuse me
137 Dressed to the nines
138 Loose cannon
139 Bags under the eyes
140 Lighten-up
141 A chip off the old block
142 The jokes on you
143 Forty winks
144 Fell off the back of a lorry
145 High as a kite
146 A lovely bunch of coconuts
147 Unfinished symphony
148 Put your foot in it
149 Blue in the face
150 A maiden over

151 Au pair
152 Far be it from me…
153 Bury the hatchet
154 A bit on the side
155 Matinee
156 Painting by numbers
157 An open and shut case
158 Beeline
159 Hair standing on end
160 Who's the daddy?
161 Safety in numbers
162 Family-run
163 Pull yourself together
164 Corner shop
165 Open all hours
166 A leap in the dark
167 The middle of nowhere
168 Going backwards
169 Draw a line under it
170 Parting shot
171 Back to front